# GEORGE BELLOWS

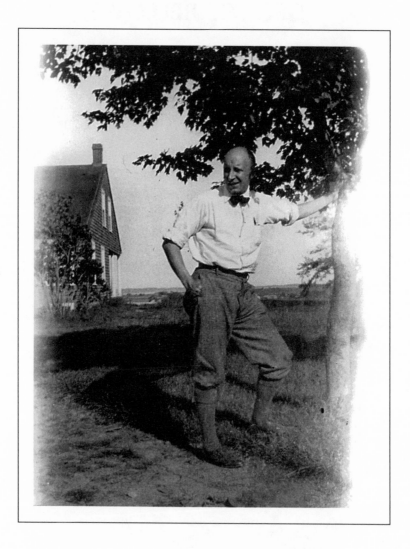

# GEORGE BELLOWS: AMERICAN ARTIST

## JOYCE CAROL OATES

THE ECCO PRESS

■ ────────────────────────────────────────────

## Acknowledgments

Portions of the sections on the boxing paintings "Stag at Sharkey's" and "Dempsey and Firpo" are drawn from the author's "George Bellows: The Boxing Paintings," originally published in *Art & Antiques* (Summer 1987) and reprinted in *(Woman) Writer: Occasions and Opportunities* (Dutton, 1988).
Photo of George Bellows courtesy The Bellows Papers, Special Collections Department, Amherst College Library.

The Ecco Press
100 West Broad Street
Hopewell, New Jersey 08525

Published simultaneously in Canada by
Penguin Books Canada Ltd., Ontario
Printed in the United States of America

Designed by Nicola Mazzella

Library of Congress Cataloging-in-Publication Data

Oates, Joyce Carol, 1938–
    George Bellows : American artist / Joyce Carol Oates. — 1st ed.
        p.   cm.
    Includes bibliographical references.
    ISBN 0-88001-437-7
    1. Bellows, George, 1882–1925—Criticism and interpretation.
I. Title.
ND237.B45O18   1995
759.13—dc20                                        95-18278
[B]

The text of this book is set in Palatino.

9 8 7 6 5 4 3 2 1

FIRST EDITION

────────────────────────────────────────────

*for Mark Strand*

The artist's trade is to deal in illimitable experience.

—George Bellows

■

*Preface*

MY INTEREST in George Bellows as a specifically American artist, with roots in nineteenth-century transcendentalism and an alert, ever-inventive awareness of twentieth-century European modernism, began in the early 1970s, though it was not until 1987 that I first wrote of his work, and then exclusively of his famous boxing paintings. In the summer of 1992, invited by the Whitney Museum in New York to present Bellows in a lecture commemorating the ambitious exhibit *The Paintings of George Bellows*, I undertook a systematic study of his work. Ironically, I saw the exhibit first at the Los Angeles County Museum of Art, where it originated, in May 1992, only two weeks after the Los Angeles riot. Stepping out of the agitated atmosphere of the city to concentrate upon the work of an East Coast artist who had died in 1925 allowed me to feel more pointedly than ever before the distance between the culture of art and what might be called the life of the street—the life of the ghetto, the disenfranchised of America; the tension, always with us, yet rarely more dramatically than at the present time, between aesthetics and politics. At such times it is impossible not to wonder: What is art's legitimate place in a society so disrupted by economic, racial, and moral injustice? Is the soul of a society fundamentally determined by its economics, and "art" a function merely of money? What, in fact, is "art"? The excrescence of a troubled society, or its very soul?

My response to Bellows' work is, of course, subjective

rather than academic; impressionistic, not scholarly. I am not an art historian (though I admire art historians immensely, and envy them their "work": professional lives spent amidst visual beauty and mystery) and have made no attempt, in presenting Bellows even in his fascinating complexity, to discuss his numerous theories of composition and color, which mark him as one of the most restlessly intellectual of American artists, of his time or any other. My fascination with the full range of Bellows' work is obvious from the text to follow, yet, in certain aspects, it remains mysterious in origin, even now.

JCO, February 1995

# 1.   The Eros of the Eye

WHAT IS art, that we should honor it?

Why do some among us, singularly blessed, or accursed, so passionately devote ourselves to art that our very identities are consumed by it?

Is this destiny, or fate?

Art: the individual's extraction of meaning out of a welter of competing experiences, impressions, and images; in memorable art, the imposition of a unique imagination upon the fleeting and ephemeral—the memorialization of elemental forces in life which, having no permanent language or iconography, require art to be known at all.

*The Eros of the eye that is visual art:* striking the viewer so deeply, with such authority, the merely personal is obliterated; something like an archetypal self is evoked.

The Eros of the eye/I.

*Every man's condition is a solution in hieroglyphics to those inquiries he would put. He acts it as life before he apprehends it as truth.*

—Ralph Waldo Emerson, "Nature" (1836)

## 2. *George Bellows (1882–1925)*

THE FIRST shock you experience seeing a major exhibit of George Bellows' work is its high quality.

The second, its quantity.

The third, which distinguishes Bellows from the majority of his renowned contemporaries, among them Edward Hopper, Georgia O'Keeffe, John Marin, is the remarkable diversity of his work. In vain you seek a characteristic Bellows signature; a predictable technique, tone, subject matter, locale. Hopper, for instance, developed his painterly vision early in his career and continued for decades to create virtually the same kinds of paintings, varying only his subject matter, and that minimally. By contrast, Bellows was always questing, always probing; in his work we see the very poetry of American realism of the early, turbulent years of the twentieth century—unless we are seeing a brilliantly premeditated painterly mysticism, American as well, but rooted in mid-nineteenth-century transcendentalism. Above all we see the volcanic purity of the "creative impulse"—the primordial energy, excitation.

What is art? Bellows described it as *the marshaling of all one's faculties, including those we are unconscious of possessing.*

## 3.   *"Stag at Sharkey's" (1909)*

Art must tell a story.

—George Bellows

THIS FAMOUS painting is the work that brought the twenty-eight-year-old George Bellows, star pupil of Robert Henri, to the controversy and prominence that would characterize his reputation for years. Shown in New York in 1910, in the Exhibition of Independent Artists, it dominated the conventional canvases surrounding it and spoke for a bold new era in American art: the formally sophisticated presentation of the dynamic, the authentic, the brutal, the vulgar, the flamboyantly masculine, the indisputably "real."

Here is an Eros of the body, its pain and ignominy no less than its nobility: the "turbulent, fleshy, sensual, eating, drinking and breeding" of which Walt Whitman prophetically wrote in *Leaves of Grass.* No manly heroism here, only brutal desperation; no gentlemanly art of self-defense, only two fighters pitted together for the blood-lusty delectation of the crowd, with the hope of winning a purse, however meager. Like an earlier canvas of Bellows', "Club Night" (1907), which also drew a good deal of attention when first exhibited, "Stag at Sharkey's" impressionistically renders a fleeting moment of uncalculated, reflexive action, a Dionysian frenzy of faceless bodies hurtling together in virtual midair. It allowed for a virtuoso display of the young painter's talent: his fearlessness in taking on a spectacular subject, and his brilliance in executing it. Note the formal

unity of the composition, the men's bodies highlighted in the ring, the boxers' luridly pale flesh, rough-smudged whites (men's shirts), slick-glistening red (blood on both boxers and on several ringside spectators), areas of intense light and shadow. The illusion is that the artist (and by extension the viewer) is physically present at ringside, not coolly detached from the violence but vicariously, voyeuristically participating in it.

The blurred faces and dreamlike sketchy figures suggest the nightmare of Goya's fantastical etchings, in which man's savage inhumanity to man is dramatized, in a luridly public, spotlighted arena. The artist has purposefully left parts of the boxers' bodies uncompleted, to suggest rapidity of movement, and the typical ringside confusion of seeing more than can be immediately processed, absorbed, and understood. "Club Night" is an even murkier canvas, the heads, shoulders, and gloves of the struggling boxers highlighted, with subtle tones of smudged blood-red, amid a packed, anonymous interior. Yet more savagely ironic is "Both Members of This Club" (1909), a similar painting, in which a white boxer and a black boxer fiercely contend, their muscled bodies trembling with tension and glistening in sweat and blood. (Of course, at the time, as well into the 1960s, "whites" and "blacks" rarely mingled, in sporting clubs or elsewhere.) Bellows' title is ironically taken, that both races are members of *this* club—a private establishment catering in unmediated violence for the sadistic entertainment of the white masculine crowd. Like George Luk's "The Wrestlers" (1905), these striking early paintings of Bellows' depict men as wholly physical beings, killer brothers, or twins, trapped in the madness of mutual self-destruction.

These are Goyaesque images of the American city as well. The canvases were painted at a time when boxing was illegal in New York State—a time, it's said, when more boxing matches took place weekly than ever before or since. In these private clubs, under police "protection," men of disparate ages, weights, and experience were matched; there were no enforced regulations; no ringside doctors, of course; and referees rarely stopped fights. If a boxer died, his body was summarily dumped in an alley or in the river, without identification. This is New York City, the hellish perversion of the American dream, its slum life powerfully depicted in other, even more crowded canvases of Bellows', as in Stephen Crane's *Maggie: A Girl of the Streets* (1896).

What more visually compelling metaphor of man's aggression than the boxing ring? What more immediately striking image, for a fiercely ambitious and competitive young artist from the Midwest, involved in his own struggle for recognition? As Bellows cryptically remarked, "I don't know anything about boxing. I'm just painting two men trying to kill each other."

## 4. *Genius . . .*

> Born to thrive by interchange
> Of peace and excitation.
>
> —William Wordsworth, *The Prelude*, Book XIII

## 5.  *Driven*

What the world needs is Art, Art, and more Art.

—George Bellows

OF AMERICAN artists of the first rank, none had a more tragically foreshortened career than Bellows. He died, unexpectedly, of a ruptured appendix, aged forty-two; the most famous American artist of his time. In the single year 1924, he painted several of his most ambitious and enigmatic canvases: the celebrated "Dempsey and Firpo," the experimental portrait "Lady Jean," the unnerving double portrait "Mr. and Mrs. Philip Wase," and the opulently surreal "Two Women," a work as mysterious as any by De Chirico or Magritte. At the time of his death, Bellows was ever ascending in his technical mastery; ever more original and innovative in his painterly vision. It's both futile and irresistible to speculate what Bellows might have accomplished with an additional forty-two years of life and work, had he died in 1986—like his exact contemporary Edward Hopper.

As it is, in even his truncated career, Bellows left more than six hundred finished oil paintings and thousands of drawings and lithographs. Clearly, he was a driven man, under the spell of an elusive Daimon; friends and associates testified to his prodigious energies, his ambition. (He had hoped to be a commercially successful portrait painter, a career for which he was temperamentally ill suited.) His passion for aesthetic theories ("Dynamic Symmetry," color and compositional systems, etc.) seems to have been insatiable. Bellows was a man in the grip of

a compulsion to ceaselessly reimagine and reinvent himself; one of those gifted (or accursed) personalities for whom the primary condition of life is dissatisfaction, tension. *There is no new thing proposed, relating to my art . . . I will not consider,* he once said. Bellows devoured theories the way other artists devour, or are devoured by, sexual predation.

Though we should guess it from the evidence of his art, the dazzling surface motility of the early boxing works, in which visceral sensation is communicated in rough, seemingly unstudied brushstrokes, the seething, churning, virtually palpitating seascapes ("The Sea," "Churn and Break," "Beating Out to Sea," "Fog Rainbow," "Monhegan Island," "Wave," "Summer Surf"), the hyperthermic intensity of the symbolist-allegorical canvases ("The Big Dory," "Fisherman's Family," "Two Women"), the primitive animism of the New York river- and cityscapes ("River Rats," "Forty-Two Kids," "New York," "Cliff Dwellers"), Bellows' letters frankly attest to his rapid swings of emotion; his oscillating from a fever pitch of excitement, about a new aesthetic theory for instance, to a sharp disappointment in the theory's execution. Subject to shifting tides of energy, not unlike the tides of the Atlantic which he so frequently painted, a systolic/diastolic swing from *excitation* to *peace* to *excitation* to *peace* to *excitation,* Bellows strikes us as a man in the grip of the unconscious, who exerts control by intellectualizing his material; a man of immense passion who falls in love again, again, again . . . each time the first time, each experience absolved in innocence. Unfortunately, this kind of passion can become mania, and not Wordsworthian peace but clinical depression can follow. (In

such phases, Bellows sometimes destroyed the very paintings that had been his favorites: an act of displaced suicide.)

What *is* art, that we should honor it by surrendering ourselves to it, not once but numberless times?

## 6.   *Walt Whitman, Kosmos, of Manhattan the Son . . .*

I celebrate myself and sing myself
And what I assume you shall assume,
For every atom belonging to me as good belongs to
    you.
. . .
There was never any more inception than there is now,
Nor any more youth or age than there is now,
And will never be any more perfection than there is
    now,
Nor any more heaven or hell than there is now.

Urge and urge and urge,
Always the procreant urge of the world.
. . .

I am of old and young, of the foolish as much as the
    wise,
Regardless of others, ever regardful of others,
Maternal as well as paternal, a child as well as a man.
Stuff'd with the stuff that is coarse and stuff'd with the
    stuff that is fine. . . .

Dazzling and tremendous how the sunrise would kill
    me,
If I could not now and always send the sunrise out of
    me.

We also ascend dazzling and tremendous as the sun,
We found our own O my soul in the calm and cool of
    the day-break.

. . .

I have said that the soul is not more than the body,
And I have said that the body is not more than the
    soul.

. . .

I hear and behold God in every object, yet understand
    God not in the least,
Nor do I understand who there can be more wonderful
    than myself.

Why should I wish to see God better than this day?
. . .

"Song of Myself" (1855, 1881)

## 7.   *In New York: "The Lone Tenement" (1909)*

There is beauty in everything if it looks beautiful in
your eyes.

—Robert Henri

BORN IN Columbus, Ohio, in 1882, the twenty-two-year-old
George Bellows journeyed east in 1904, against his conserva-
tive father's wishes, to become a professional artist. Initially, he
hoped to be an illustrator; certain of his early works, like compa-
rable anecdotal works of Winslow Homer's, betray the
illustrator's ease of execution and the wry, ironic detachment of
the artist from his subject. (See Bellows' "Forty-Two Kids,"
1907, the portrait "Paddy Flannigan," 1908, the Hogarthian
depiction of Reverend Billy Sunday's revival campaign "The
Sawdust Trail," 1916.) Yet even here there are masterful touches
that raise the canvases far above the level of illustration: the
brooding dark that is in fact the river into which naked, swarm-
ing boys plunge like animals, the irrepressible life of the street
urchin Paddy Flannigan, the complex organization of shapes,
lines, and colors of "The Sawdust Trail," with its allusion to El
Greco's masterpiece, "The Burial of the Count of Orgaz." From
the first, Bellows was ambitious.

In New York, the young artist quickly changed his concept
of art, and of himself, completely. Now art became a destiny, the
means for vivid self-expression; a way of realizing his appar-
ently inexhaustible talent. The continual influx of new arrivals,
including immigrants, the sharp, dramatic division between so-

cial classes, the strife and visual wonders of urban life—New York at the turn of the century was transforming. Bellows enrolled in the New York School of Art where he was fortunate enough to study with the influential and charismatic Robert Henri. Like Thomas Eakins of a previous generation, Henri violated conventions of art school decorum by sending his pupils into the streets, including the Bowery, in search of "the real" and "beauty"—a celebration, in Whitmanesque terms, of *God in every object;* the life force in its most primitive, irresistible forms.

Said Bellows of his encounter with Henri, "My life begins at this point."

With what exuberance and curiosity the young artist prowled the busy streets, parks and squares, ghetto neighborhoods, excavation sites, saloons and boxing clubs and riverside docks of Manhattan, judging from the remarkable work of these years! Clearly, Bellows was under the spell of the city; charged by it, brilliantly inspired by it. The expansive, panoramic canvases "River Rats" (1906), "Excavation at Night" (1908), "New York" (1911), the crowded and claustrophobic "Cliff Dwellers" (1913), and the controversial lithograph for the radical magazine *The Masses,* "Why Don't They Go to the Country for a Vacation?" (1913) belong to this period. Bellows' New York works are reportorial in content, poetic-impressionistic in technique and mood, in the mode of gritty urban realism that Henri urged upon his students, yet subtly distorted, even hallucinatory, like the mysterious, elegiac "The Lone Tenement" (1909) in which diminished male figures (men, boys) stand singly or in lethargic

clusters in a vast empty space below the Blackwell's Island Bridge (now the Queensboro Bridge), all faceless, anonymous. A tall, isolated tenement building of no architectural distinction looms over them like the shadow of their own unconsidered mortality; the painting's dynamism lies in its compositional values of contrasting sunshine and shadow, and its sole "action" is the spirited rising of smoke from a distant boat on the river. Somber, seemingly crude and "inartistic," this early canvas, painted in the same year as "Stag at Sharkey's," suggests a radical revisioning of American landscape; the antithesis of the showy, grandly mystical vistas of Bellows' nineteenth-century predecessors of the Hudson Valley and the luminist schools. "The Lone Tenement" contrasts even with another canvas of Bellows' of the same year, of the view from beneath Blackwell's Island Bridge, a more obviously painterly, impressionistic, and commercial work, "The Bridge, Blackwell's Island" (1909). In this painting, a strangely cobalt-blue river flows majestically beneath a leaden sky; well-dressed observers stand at a park railing, watching the passage of several boats. The mood of the painting is robust, vigorous, gusty, bracing—set beside "The Lone Tenement," a mere exercise in composition and color.

"The Lone Tenement" with its sharp shadows and isolated figures seems to look ahead: to the equally isolated and curiously dignified figures, both human and architectural, of Edward Hopper; and to such symbolist-poetic works of Bellows' as "Shore House" (1911) and "In a Rowboat" (1916). It is a testament to a certain sort of American-urban melancholy: disturbing, unglamorous, yet strangely beautiful, in the dreamlike manner of Bellows' European contemporary De Chirico, the quintessential

poet of inner space and solitude. Yet "The Lone Tenement" remains wonderfully, firmly rooted, like all of Bellows' work, in a solid and seemingly historic reality.

*I hear and behold God in every object, yet understand God not in the least.*

## 8.    *Leaves of Grass*

ONE OF the texts Robert Henri read aloud to his students was Whitman's *Leaves of Grass*. This Dionysian-incantatory celebration of America—"The United States themselves are essentially the greatest poem"—and of "Nature without check with original energy" was yet a controversial work in the early 1900s; not merely a scandalous literary document but a moral challenge, an aesthetic call to arms that would revolutionize American poetry. To George Bellows and his coevals, Walt Whitman's assured, vatic, exclamatory voice must have seemed the voice of the new century, and of Manhattan in particular; *Leaves of Grass* is a bold, even reckless prophetic work whose intention is to redefine the soul of America, as distinct from a European-defined America.

And that rhapsodic, bombastic, rambling, and fantastical *Preface*, how like the utterances of a God-obsessed Old Testament prophet, a lost book of the Bible, perhaps—

> The Americans . . . have probably the fullest poetic nature. . . . Here is not merely a nation but a teeming nation of nations. . . . Here are the roughs and beards and space and ruggedness and nonchalance that the soul loves. . . . The genius of the United States is . . . most in the common people. Their manners speech dress friendships—the freshness and candor of their physiognomy—the picturesque looseness of their carriage. . . . As if the beauty and sacredness of the demonstrable must fall behind that of the mythical! As if men do not make their mark out of any

times! . . . (The great poet) is no arguer . . . he is judgment. He judges not as the judge judges but as the sun falling around a helpless thing. . . . He sees eternity in men and women . . . he does not see men and women as dreams or dots. . . . Who knows the curious mystery of the eyesight? . . . What is marvelous? what is unlikely? . . . The messages of great poets to each man and woman are, Come to us on equal terms. Only then can you understand us. We are no better than you. . . . Did you suppose there could be only one Supreme? . . . The spirit receives from the body just as much as it gives to the body. . . . A great poem is for ages and ages in common and for all degrees and complexions and all departments and sects and for a woman as much as a man and for a man as much as a woman. . . .

And more, much more.

Whitman's robust, unswervingly optimistic mysticism, leavened with its air of public-preacher oratory, is a mysticism capacious enough to embrace even death, disorder, pain, and suffering as a part of the "Kosmos." Here, the airiness of Ralph Waldo Emerson and New England transcendentalism is given a physical being, a palpable, visceral, tactile soul. To see the American people as "unrhymed poetry" awaiting a "gigantic and generous treatment of it"—to see beauty in savagery, nobility in ruins—"a call in the midst of the crowd"—is to be inspired in the deepest, root sense of the word, in-breathed by another's spirit.

## 9.    "Forty-Two Kids" (1907), "River Rats" (1906)

The Whitmanesque vision of art's grand prospects, never quite bluntly stated, is that the poet/artist does not simply record what *is*, but contributes to creating it. The poet/artist mediates between what *is* and the human soul. In the soaring, ecstatic, just slightly mad rhetoric of the *Preface* to *Leaves of Grass*, the poet is very like God (in whom, cautiously, he neither believes nor disbelieves, and about whom he refuses to argue). The universe is a dream of American democracy as "democracy" is a dream of American rhetoric, hardly closer to fruition in our time than it was in Walt Whitman's time, or in the early, formative years of the twentieth century; yet it is essential for the poet/artist to believe, for otherwise he is in danger of detaching himself from his subject, of falling into cynicism. The *compulsiveness* of Whitman's optimism. The *megalomaniacal claims* of the "great poet"!

Still, we yearn to believe.

The spirit of Whitman, indiscriminate, indiscreet, glorying in what might (and did) repel others, pervades those paintings and lithographs of Bellows' generated by his years in New York, as a witness, on the street, and in such places as Sharkey's, to the dazzling variousness of humanity. By choosing to depict ghetto street scenes of alarming congestion ("Why Don't They Go to the Country for a Vacation?" reduces men, women, children of the Lower East Side to virtual insects) and painting, with a soft, meditative, and almost romantic palette, urchin boys and derelicts en masse, Bellows tested the perimeters of what art

is or should be. His painting of "dock rats"—"Forty-Two Kids"—caused a sensation in 1908 when it was denied a prize at the Pennsylvania Academy because of its "offensive" subject matter (that is, naked slum boys). A typical reaction to this painting was that of a prominent critic who dismissed it as "a tour de force of absurdity—a graphic impression of a lot of boys diving off a wharf, in which most of the boys look more like maggots than humans."

In fact, the boys of Bellows' carefully composed painting look nothing at all like maggots, but simply like naked boys, young teenagers, seen at a distance of about thirty feet. Bellows renders them without judgment, nor even amusement, though the canvas appears, at a superficial glance, to be an anecdotal, good-natured illustration in a popular style. Given its boister-ous, rowdy setting, the spectacle of boys yelling as they dive into a murky, polluted body of water, the painting is strangely somber, subdued. All the boys are physically absorbed in their activities; only a few stand alone, one smoking a cigarette (just barely discernible jutting from his mouth); they are almost literally swallowed up by the featureless dark of the river behind and (a trick of perspective) ominously above them, the East River most likely, despoiled, unfit for swimming for any but slum kids. How deliberately Bellows has chosen these melan-choly, even autumnal colors, in which vulnerable human flesh (unnaturally pale, tan, darkly tanned) fades into the browns, sepias, and shadowy blacks of the river's background, as in a cinematic dissolve! The artist's decision to forgo bright, more "natural" colors is evident if we compare "Forty-Two Kids" to genre paintings and illustrations of the time; to, for instance,

certain of Winslow Homer's sunlit, just-verging-on-the-sentimental depictions of farm boys and girls of the 1870s. Bellows' mock-pastoral suggests the "twenty-eight young men" of *Leaves of Grass* who bathe naked by the shore as a lonely young woman looks on with wan erotic yearning. (In fact, there are not forty-two boys in the painting, more like less than thirty.) But Whitman's sexual exuberance is totally missing from this subdued urban scene. And there is no focusing of any special point of view, no suggested emotional tone.

Yet more disturbing is "River Rats" (1906), whose perspective is so distant that the bathing boys, at the very bottom of the canvas, do indeed resemble hairless rats. Though the canvas is considerably smaller than "Forty-Two Kids," it is in fact more ambitious in scale and composition; the boys are merely part of a vast, devastated-looking landscape, an eroded hill or raw excavation dropping sharply, a distance of perhaps one hundred feet, from a slummy urban area above, indistinctly rendered as in smog. By so removing himself from the boys, his ostensible subject, the artist sees them as undistinguished from the broad, raw, inhuman forces that surround them. This is "real life"—a "slum project" of the kind initiated by Robert Henri— yet there is a brooding, somber beauty to it; a sense that the rhapsodic pantheism or animism of which Whitman spoke with such passion might take, in the American city of the twentieth century, another, more morally ambiguous form.

## 10.    *Multitudes*

He invaded the turmoil and tumble of the down-
town streets, and learned to breathe maledictory
defiance at the police, who occasionally used to
climb up, drag him from his perch, and punch him.
In the lower part of the city he daily involved him-
self in hideous tangles. . . . He fell into the habit,
when starting on a long journey, of fixing his eye
on a high and distant object, commanding his
horses to start, and then going into a trance of ob-
livion. Multitudes of drivers might howl in his rear,
and passengers might load him with opprobrium,
but he would not awaken until some blue police-
man . . . began to seize bridles and beat the soft
noses of the responsible horses.

. . . Foot passengers were mere pestering flies
with an insane disregard for their legs and his conve-
nience. He could not comprehend their desire to
cross the streets. Their madness smote him with eter-
nal amazement.

. . . Yet he achieved a respect for a fire-engine.
As one charged toward his truck, he would drive
fearfully upon a sidewalk, threatening untold people
with annihilation. . . . A fire-truck was enshrined in
his heart as an appalling thing that he loved with a
distant, doglike devotion. It had been known to
overthrow a street-car. . . . The clang of the

gong pierced his breast like the noise of remem-
bered war.

from *Maggie: A Girl of the Streets* (1896)
by Stephen Crane

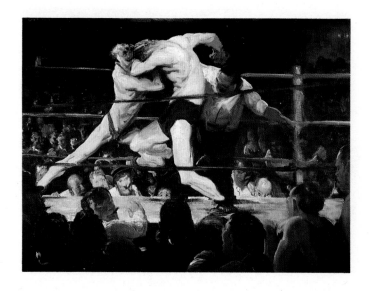

*Stag at Sharkey's, 1909*. The Cleveland Museum of Art, Cleveland, Ohio; Hinman B. Hurlbut Collection.

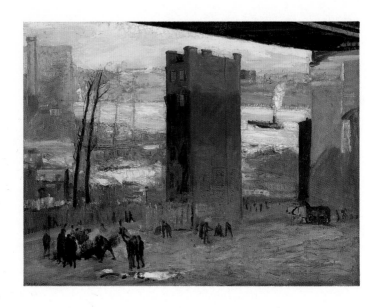

*The Lone Tenement, 1909.* Board of Trustees, National Gallery of Art, Washington, D.C.; Chester Dale Collection.

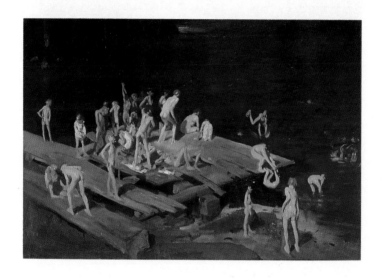

*Forty-Two Kids*, 1907. Corcoran Gallery of Art, Washington, D.C.; Museum purchase, William A. Clark Fund.

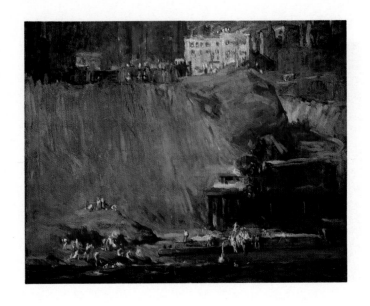

*River Rats,* 1906. Private collection, Washington, D.C.; printed
by permission.

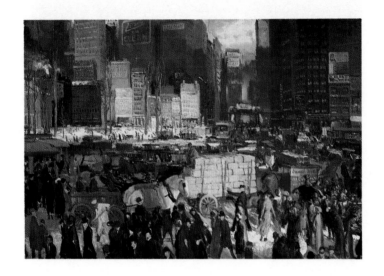

*New York*, *1911*. Board of Trustees, National Gallery of Art, Washington, D.C.; Collection of Mr. and Mrs. Paul Mellon.

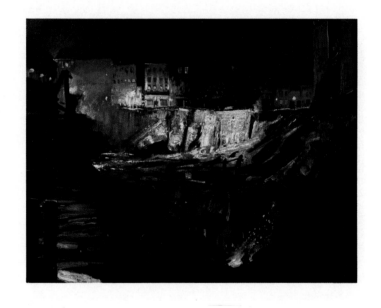

*Excavation at Night*, 1908. Courtesy of the Berry-Hill Galleries, New York.

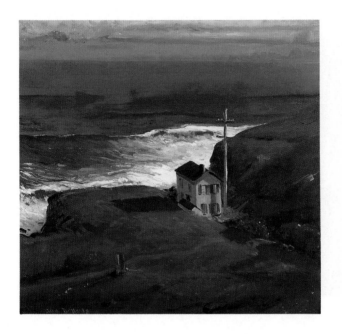

*Shore House,* 1911. Collection of Rita and Daniel Fraad.

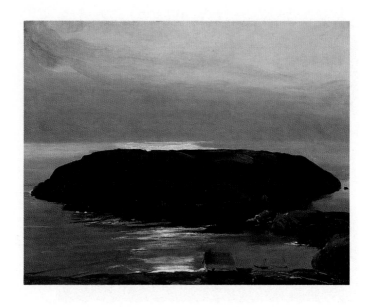

*An Island in the Sea*, 1911. Courtesy Columbus Museum of Art, Columbus, Ohio; gift of Howard B. Monett.

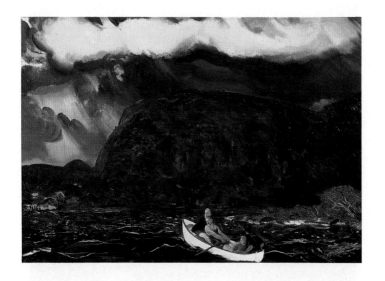

*In a Rowboat*, 1916. Montclair Art Museum, Montclair, New Jersey; purchase made possible through a special gift from Mr. and Mrs. H. St. John Webb.

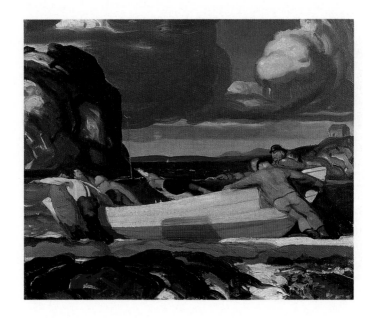

*The Big Dory*, 1913. New Britain Museum of American Art, New Britain, Connecticut; Harriet Russell Stanley Fund.

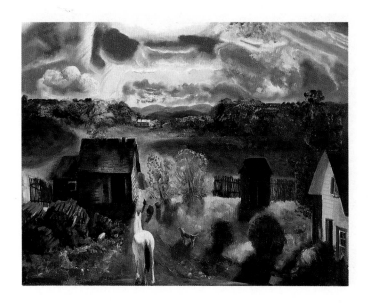

*The White Horse,* 1922. Worcester Art Museum, Worcester, Massachusetts; museum purchase.

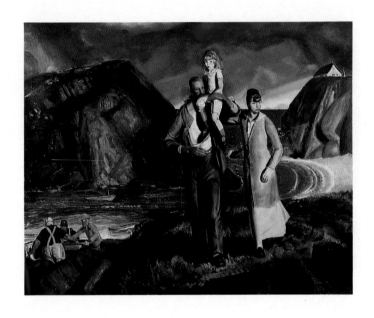

*Fisherman's Family*, 1923. Private collection; courtesy of Kennedy Galleries, New York.

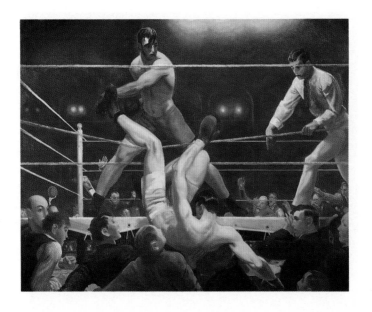

*Dempsey and Firpo*, 1924. Whitney Museum of American Art, New York; purchase, with funds from Gertrude Vanderbilt Whitney.

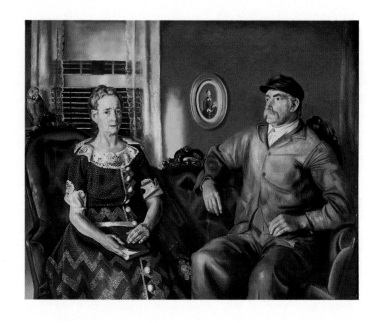

*Mr. and Mrs. Philip Wase, 1924.* National Museum of American Art, Smithsonian Institution, Washington, D.C.; gift of Paul Mellon.

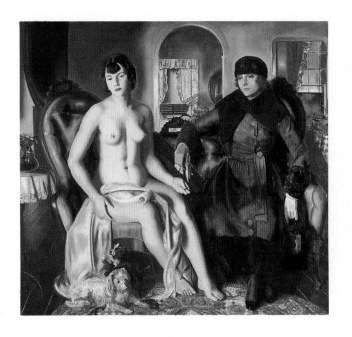

*Two Women*, 1924. Portland Museum of Art, Portland, Maine; lent by Karl Jaeger, Tamara Jaeger, and Kerena Jaeger.

*The Picket Fence*, 1924. Davis Museum and Cultural Center, Wellesley College, Wellesley, Massachusetts; gift of Mr. and Mrs. Chauncey L. Waddell (Catherine Hughes, Class of 1920).

## 11.    "New York" (1911), "Excavation at Night" (1908)

IT IS a demonic animism that shudders to life in Bellows' dense, congested paintings of the city, not the eroticized mysticism of Whitman or the poetic-philosophical epiphanies of the earlier transcendentalists. How humanized, how airily pastoral the famous vision of Emerson's:

> Standing on the bare ground,—my head bathed by the blithe air, and uplifted into infinite space,—all mean egotism vanishes. I become a transparent eyeball; I am nothing; I see all; the currents of the Universal Being circulate through me; I am part or parcel of God.

> from "Nature" (1836)

Bellows can be linked temperamentally with such "Darwinian" realists as Stephen Crane, whose *Maggie: A Girl of the Streets* dramatized both the crude vigor of urban life as well as its pathos, and Theodore Dreiser, whose controversial *Sister Carrie* appeared, in an expurgated text, in 1900. The images of his struggling, faceless boxers and his anonymous "river rats" suggest the tragic victims of Upton Sinclair's best-selling *The Jungle* (1906); his congested urban vistas might be graphic illustrations of the Lower East Side tenement slums of the early 1900s of the prose fiction of Anzia Yezierka (*Hungry Hearts*, 1920; *Bread Givers*, 1925). There is a perversely ecstatic vision

in the very tumult of the city, the clamor, discomfort, and animation of Bellows' controversial "Cliff Dwellers" (1913), for instance, in which hordes of tenement dwellers press out into the street and hang from windowsills and fire escapes; from a genteel perspective (the perspective of reactionary critics) the cliff dwellers are denizens of hell, yet there is another perspective, the artist's, that honors their very anonymity.

Even more hellishly congested, its human figures smaller and less distinct, horse-drawn vehicles and trolley cars in a bedlam of thwarted motion that would have defeated even the mesmerized truck driver of Crane's *Maggie*, the large, audaciously detailed "New York" fairly throbs with vitality and force. This is one of Bellows' most scrupulously rendered vista paintings, a poeticized vision of Union Square with artfully balanced spots of red, green, yellow, white; at the center is a truck bearing a cargo of luminous-pale yellow boxes (bales of hay?), at an apparent standstill in impacted traffic. Tall buildings of dreamlike pastoral hues yearn upward in the distance (uptown toward Broadway?) and fade into the smoky horizon and the featureless sky with a delicacy more commonly associated with the translucent medium of watercolor than with Bellows' favored medium, oils. In the foreground, however, so seemingly close that one can nearly hear the din of clattering wheels over cobblestone, a policeman's whistle, scattered shouts and cries, is a stylized nightmare of urban density in which individual men and women, many of them uniformly dressed in dark clothes, are blurred, anonymous figures like upright ants. "New York" strikes the contemporary eye as an imaginative artist's rendering of a complex social (and moral) city scene, with obvious

references to impressionistic models of similar densely populated Parisian scenes; yet, to the art critics of Bellows' time, it represented "too harsh an insistence upon the raw facts of the street scene" and was denounced, however improbably, as "ugly" and "grimy"! Even so, at least one sympathetic critic predicted that Bellows' "New York" would one day in the future be singled out as "the best depiction of the casual New York scene left by the reporters of the present day." As if such photographic *literalism* is the artist's, and art's, supreme ideal.

Bellows' masterwork of the exterior New York–vista scene, however, is the dark, mysteriously illuminated canvas "Excavation at Night." In this powerful work, with its immediate symbolist-poetic look, we see, from an apparently aerial perspective, an immense crater in the earth in which a nighttime fire is burning in front of a workmen's shed; human figures, in silhouette, are all but invisible around it. The gouged-up landscape is smudged and indistinct, with a look as of a great cataclysm; the facades of buildings at a distance, on the rim of the pit, appear to shimmer with florid, demonic flashes of unexpectedly beautiful colors—pale red, pale yellow, olive-green, an idyllic fading blue-gray like a remembered sky. Smoke seems to be rising from the pit, dissolving into the murky air. The suggestion of hell, a manmade inferno of distorted shapes, almost entirely dehumanized, is dramatically understated.

"Excavation at Night" is an impressionistic transcription of an ongoing urban project of years (1907–1909), the building of Pennsylvania Station, of much interest to New Yorkers, and to George Bellows. (A four-square-block area between Thirty-first and Thirty-third streets and between Seventh and Ninth ave-

nues was razed and a gigantic hole gouged out of the earth before construction began.) Working from numerous sketches made at the scene, Bellows painted the complex, dreamlike canvas in his studio, aided by means of an esoteric compositional system of geometric figures; it bears an elliptical relationship to the murky, claustrophobic yet brilliantly rendered (with similar balancing and highlighting touches of "red-radiance") boxing paintings of 1907–1909.

In these New York paintings of George Bellows, which made him famous as a young artist and assured his position in American art as a representative "realist" of his time—a restrictive and misleading category that prevails in most histories of American art to this day—we can see, in retrospect, with retrospect's sagacity, the direction in which Bellows' major art would move: toward symbolist forms, and away from populist literalism; toward stylized and even allegorical figures, of which the "human" and the "actual" are but representations (however gorgeously rendered); toward the evocation of mood, mystery, an Eros of the eye in which all the artist's faculties *including those he is unconscious of possessing* are given a triumphant form, a life finally independent of the artist.

## 12.   *The Lair of the Sea Eagle*

I climbed into the Lair of the sea eagle where human foot had never trod, and then what do you think happened? I lay on the ledge for a while in some soft long grass watching the clouds above and the mighty sea far below, when suddenly the thought got into my head: suppose that—and just as suddenly I arose and climbed out again.

—George Bellows, from Monhegan Island, Maine, 1911

## 13. "Shore House" (1911), "An Island in the Sea" (1911)

THE EVIDENCE that George Bellows restlessly reimagined his art, and himself as the lens for such reimagining, is in the abrupt transitions between canvases painted at very nearly the same period of time, but in different places. How radically different in tone, style, and consciousness from the more dynamic and ingeniously organized New York paintings is this dreamlike "Shore House," which was first sketched at Montauk Point, Long Island, in the summer of 1910, and painted in January 1911. How like a lost painting by Edward Hopper (whose early major work was done in the 1920s): a scene of profound yet unsettling simplicity, rather flat, smooth shapes lacking texture and definition, as a child might imagine them, or memory record them. Here is an art not of psychic participation but of reflection. In this pastoral vision of Nature, in which humankind appears by metonymical displacement, as a blue-shadowed house, the "demonic animism" of the city has no place.

"Shore House," like Hopper's great paintings of solitude, is a riddlesome work that repays many viewings. It is a meditation; a poem; an elegy in blues, primer green, dun colors of brown. A single grotesquely tall and oddly shaped telephone pole stands much too close beside a two-story wood frame house square as a box; there seems to be no road or drive leading to the house, and no suggestion of other telephone poles. The only dynamism in the scene is that of immense snowy-capped waves that break silently upon an unseen beach below the sea cliff; the viewer's perspective seems to be aerial,

a hill some distance away. The painting is almost exactly divided, at a diagonal, between dun-colored earth (dried, sere vegetation like broom grass?) and the virtually indistinguishable sea/sky, of a gorgeous pellucid blue. The "shore house," a mere human habitation amid such expanses, seems but an excrescence in Nature, diminished and ephemeral, without identity. So too the imagined human presence (the envisioning artist's): muted, isolated, a witness at a distance.

Isolation, silence. Mystery. The blue house is the "human"—inhabiting its finite space with a peculiar dignity. It is of no consequence—yet of great consequence. For without it, without the artist's witnessing vision, there could be no composition at all: Nature devoid of (human) consciousness.

An even greater silence and mystery pervades "An Island in the Sea" of the same year (amazingly, Bellows completed over one hundred canvases in 1911). Here, a small, seemingly incidental "shore house" positioned in the very foreground, bottom of the scene, is overwhelmed by an immense, darkly ominous and seemingly floating loaf-shaped island in a great immensity of pale-glimmering sea, sky, and reflecting light (an etiolated sun, a luminous moon?). The human habitation here is hardly more than a suggestive shape, a steep-pitched gray roof, a narrow smudged-white side. All the painting's colors are muted and neutral; vegetation is minimal, a dull green. If "Shore House" suggests Edward Hopper, "An Island in the Sea" suggests the more surreal of Winslow Homer's oils and watercolors and the eerie visionary dreamscapes of Albert Pinkham Ryder.

## 14.   *Seductions*

Our . . . life would stagnate if it were not for the unexplored forests and meadows which surround it. We need the tonic of wildness . . . we require that all things be mysterious and unexplorable, that land and sea be infinitely wild, unsurveyed and unfathomed by us because unfathomable. We can never have enough of Nature. We must be refreshed by the sight of inexhaustible vigor, vast and Titanic features. . . . We need to witness our own limits transgressed, and some life pasturing freely where we never wander. We are cheered when we observe the vulture feeding on the carrion which disgusts and disheartens us and deriving health and strength from the repast. . . . I love to see that Nature is so rife with life that myriads can be afforded to be sacrificed and suffered to prey upon one another; that tender organizations can be so serenely squashed out of existence like pulp . . . and that sometimes it has rained flesh and blood!

The universe is wider than our views of it.

> —Henry David Thoreau, "Spring" and
> "Conclusion," *Walden*

. . . that hag of a sea . . . its insidious feminine seductions.

> —George Bellows, letter (1913)

## 15.    "Wonderful Meanings"

BOLD, STARK, surreal colors, images, and painterly techniques characterize Bellows' remarkable seascapes of 1911–1916. Here, the subject is less the sea itself than the artist's (mankind's) apprehension of the sea; its "seductions" transposed into all but palpable, throbbing, visceral sensations. What extraordinary canvases! A crude life leaps from them, a ravishing of the eye. The demonic animism of Bellows' renowned cityscapes becomes, in this sequence of works, homage to the mysterious and terrifying powers of Nature, over which the artist has no more control than he does over his own unarticulated passions.

This Bellows, the visionary Bellows, spiritually akin to such experimental artists as Van Gogh, Gauguin, Derain, Kirchner, and Nolde, is relatively unknown even to admirers of American art. Here he is a poet of harsh epiphanies, a poet of dreamscapes, violent emotions. If a realist, a "magic realist." An expressionist (an artist not passive before the world, like the impressionists, but actively engaged in shaping it). We know from Bellows' letters that he intended deep, symbolic, ineffable meanings—*wonderful meanings*—to be evoked by these seascapes.

Too many to consider individually, Bellows' seacoast paintings repay many viewings. "The Sea" (1911), "Gorge and Sea" (1911), "Three Rollers" (1911), "Churn and Break" (1913), "Fog Rainbow" (1913), "Monhegan Island" (1913), "Beating Out to Sea" (1913), "Kelp Rock" (1914), "Summer Surf" (1914), "The Coming Storm" (1916): In some of these, striking colors exude from waves, rocks, skies; livid brushstrokes suggest impa-

tience, even passion; "natural" shapes are subtly distorted, on the verge of abstraction; where human figures appear, they are dwarfed by their surroundings. Several of these are dark, or darkly luminous paintings; others are works of startling color; "subject" subsumed by raw emotion. My favorite is "Summer Surf" (1914), the most visually stunning of the seascapes: raw reds, red-blues, a gigantic rock ledge so rendered as to appear, at first glance, an abstract design, against which white-capped waves crash furiously. The painting is so composed as to be all diagonals, as if the very earth had been wrenched sideways; one feels the thunderous surf, at the very brink of dissolution, the dissolution of rock, earth, solid forms, "reality" itself. How strange then to see, placed in this riotous rockscape as if *inserted*, several female figures, at the far right, hardly more than quick brushstrokes of color, and these colors very like those of the convulsing rock ledges. "Summer Surf" is the antithesis of the contemplative "shore house" paintings—raw emotion, yearning, baffling and inchoate rage.

## 16.    "In a Rowboat" (1916)

ALL SERIOUS artists labor in the shadow of Death.

In the daily, hourly contemplation of two aspects of mortality: that which is universal, condemning the very species—and art—to extinction; and that which is individual, pertaining to himself (herself) alone.

The former is bearable only because the latter is, in one's innermost heart, unthinkable.

Or is the latter bearable only because the former is, in one's innermost heart, unthinkable?

Yet not Death, nor mortality exactly, accounts for the artist's peculiar temperament: the eerie admixture of childlike hope and precocious cynicism, the vulnerability to hurt, rage, despair as if one's outermost skin were peeled away, and the very *thrum* of the living blood exposed. How too to account for the artist's prototypical obsession with time?—time's pitiless "progress," the soft-sifting whisper of time's hourglass measuring duration *in one direction only.*

Not Death, nor mortality merely, can account for the artist's predilection for anxiety. *Dare you see a Soul at the White Heat?* Emily Dickinson bluntly asks in the opening, frontal line of this great poem (#365), a brilliant and surely intimate analysis of the poetic enterprise, or fate. The *White Heat* is the incandescence of creation, *the light,* in Dickinson's language, *Of unanointed Blaze*—as necessary for spiritual redemption as the terrible heat of the blacksmith's forge is necessary for the refining and shaping of crude ore. The artist's anxiety is that he (or she) will die, if not young exactly, then young in terms of the

art-potential within. W. H. Auden noted wryly that we all hope to be judged by the brilliant work-in-progress which death or disaster interrupted, even as we judge others by finished work. The horror is premature death, death in one's prime. Like George Bellows' death, in the ascendancy of one's art.

Conversely, the temptation is to feel that, if no more significant work remains, the artist has no further reason to live.

"Peace" and "excitation" of which Wordsworth speaks are ways of isolating the poles of calm/control/cerebral mastery and manic energy that fuel the artist; "peace" is mere emptiness without its counterpoint, and "excitation" mere frenzy, madness, without its counterpoint.

"In a Rowboat" is one of Bellows' major paintings, bringing into poetic concentration his most obsessive themes, yet centering them in a richly specific episode: a near disaster suffered by Bellows, his wife and daughter, and a friend, rowing in a small boat in Camden Harbor, Maine, in the summer of 1916, when a sudden squall came up. The painting is a masterful blend of impressionist technique and symbolist meaning, obliquely suggesting Winslow Homer's Prouts Neck storm canvases and his 1889 oil "The Gulf Shore." There is a grimly fabulist atmosphere to the canvas, a suggestion of the fairy tale, in which near-faceless human beings are dwarfed by danger, the sudden threat of extinction. Death is the turbulent, faintly derisive sky, the black leviathan of a mountain at shore, wildly churning waves with sharklike fins. In the foreground, virtually contiguous with the viewer (if we reach out, can we not touch the rear of the bucking boat?) is the unnaturally white rowboat, manned by a single struggling rower and three helpless passengers (the

anonymous second man, who is in fact George Bellows, the dark-clad Emma and their pink-clad little girl Anne). Piteously small and frail these human beings seem to us, pale flesh colored against the darkening light, caught up in a struggle they may well lose. The slate-blue, thinly white-capped waves are mere impatient horizontal brushstrokes, mimicking the heavy sky overhead; the featureless land mass looms ominous as a tombstone. The painting isolates a moment of particular, personal anxiety for Bellows, for not only are he and the others in imminent danger of drowning, but Bellows, husband and father, is seated behind the rower, a friend named Leon Kroll, in a paralysis of impotence; he can neither help with the rowing, nor reach out to comfort his wife and daughter (neither Mrs. Bellows nor their daughter could swim).

Borne by wind and waves away from Camden Harbor and in the direction of the open sea, the little rowboat and its passengers were doomed—except, suddenly as it had begun, the squall ceased.

Next day, in a fever of inspiration, hoping to express "the fear of it all," Bellows painted "In a Rowboat." It is significant that most of the canvas is dominated by Death, or by the threat of Death; the only salvation is the palely glimmering little boat, at the moment of crisis being borne backward, out of the very canvas, into the open sea.

*An epic of terrific nature*, Bellows called it. It was one he painted, in different guises, through his life.

## 17.   *Eternities*

. . . And everything I spoke of to you would be about Love and beauty and love again and the greatness of this nature which is in us. We two and the great sea and the mighty rocks greater than the sea and we two greater than the rocks and the sea. Four eternities.

—Bellows to his wife Emma from Monhegan Island, Maine

. . . What is the sea if it isn't terrible.

—Bellows, letter (1910)

## 18.    "The Big Dory" (1913)

> When I paint the great beginning of a ship at Cam-
> den, I feel the reverence the ship-builder has for his
> handiwork. He is creating something splendid, to
> master wind and wave, something as fine and power-
> ful as Nature's own forces. . . . He is impressed with
> his own struggle to accomplish this, and when I paint
> the colossal frame of the skeleton of his ship I want
> to put his wonder and his power into my canvas.
> . . . I am filled with awe, and I am trying to paint as
> well as he builds, to paint my emotion about him.
>
> —Bellows (1917)

Like Winslow Homer's fishermen and -women, the subject of
more than 150 oils and watercolors painted in the English
fishing village of Cullercoats (1881–1882), the Maine natives
of a number of Bellows' most striking seaside paintings are
heroic, monumental figures. How ideally suited they are to
their fierce, elemental world: not individuals so much as arche-
types, their flesh solid and sculpted, of a species seemingly
different from their urban contemporaries (and from the bour-
geois summer visitors of "Summer Surf" and "In a Rowboat").
The sturdy, muscular, dignified beings of "The Big Dory"
(1913), "The Rope (Builders of Ships)" (1916), "Shipyard Soci-
ety" (1916), "The Skeleton" (1916), and "Ox Team, Wharf at
Matinicus" (1916) remind us too of the Flemish peasants of
Brueghel, though they are never depicted condescendingly,

still less for comic or satiric effect. Bellows seems to have felt for these people the kind of romantic, passionate identification D. H. Lawrence felt for certain of his male characters, miners and farmers in close, intimate engagement with the mysterious core of life. Here are Whitman's common workingmen, gorgeously mythologized.

And how charged with tension the canvases, like the air before an electrical storm! The paintings are less expressionistic in execution than the earlier seascapes, and less abstract; but there is a curiously flat tone to them, an almost glazed shadowless surface, as if, to the artist's eye, all objects animate and inanimate are suffused with an identical energy. As in the seascapes, virtually every natural shape—clouds, trees, rocks, waves, grass—verges upon contortion. No "spiritual" dimension in this world of elemental forces, and no space for meditation or isolation; only the powerful, insatiable energies of Nature. In these scenes of common life along the Maine coast, men must cooperate with one another, in communal efforts like that of fishing, fish-cleaning, shipbuilding—see the complex organization of "Shipyard Society," for instance—in order to survive.

One of Bellows' most striking heroic paintings is "The Big Dory." In this brilliantly colored and fiercely executed canvas, faceless, anonymous men of near-identical build struggle to push a boat into the seething water; their communal effort shades into abstraction, even allegory—the dynamism of men pitted against the sea, determined to conquer the sea. These are not the disoriented, frightened summer visitors of

"In a Rowboat." We appear to be only a few yards from them, farther up on land; we identify with their effort, even as they remain turned from us, aloof and oblivious. The painting exudes an almost unbearable tension: The men are arrested *in medias res*, the full length of the boat (so strangely, dazzlingly white with a broad red stripe!) a broad horizontal across the width of the canvas, mimicking the positioning of heavy storm clouds overhead and coarsely rendered rocks in the immediate foreground. The muscular men are bent at an identical diagonal with their effort, leaning seaward, their arms outstretched. To the right, we see another shore house in the distance, hardly more than a gray, weathered shack; to the left, another of Bellows' foreboding sea cliffs, a contorted geometric shape like a storm cloud given weight and texture, of weird scintillant hues. Flashes of red (a fisherman's sleeve, highlights in the rocky foreground) give the painting a nervous, quickened pulse.

Like the equally monumental "Ox Team, Wharf at Matinicus," another remarkable canvas, "The Big Dory" is about much more than its ostensible subject. The heroism of unreflective man, perhaps; the dynamism of man involved in a primal, unmediated relationship with Nature. The paintings are beautiful in ways very different from the depopulated seascapes and from the portraits Bellows was painting at this time. The artist seems to have been striving for an American, contemporary idiom in which to render ordinary men (and the occasional woman) in terms classic as those of El Greco and Rembrandt, whose human figures he much admired. His rever-

ence and awe for his subject are subtly communicated, his emotion powerfully present. These "mythologized" Maine paintings look ahead to the yet more stylized canvases of the American regionalists Thomas Hart Benton and Grant Wood of subsequent decades.

## 19.    *Paradise: "The White Horse" (1922)*

"Heaven" has different Signs—to me—
Sometimes, I think that Noon
Is but a symbol of the Place—
And when again, at Dawn,

A mighty look runs round the World
And settles in the Hills—
An Awe if it should be like that
Upon the Ignorance steals—

The Orchard, when the Sun is on—
The Triumph of the Birds
When they together Victory make—
Some Carnivals of Clouds—

The Rapture of a finished Day—
Returning to the West—
All these—remind us of the place
That Men call "Paradise"—

Itself be fairer—we suppose—
But how Ourself, shall be
Adorned, for a Superior Grace—
Not yet, our eyes can see—

—Emily Dickinson, c. 1862

■ ─────────────────────────────────────────

And how radically different, so different as to seem the work of another artist, the luminous, delicately fantastical paintings of inland scenes, some of them executed during the same period as the "heroic" works! Here is another George Bellows, a lyric visionary. Not the violent animism of the city nor the threatening forces of Nature are here celebrated, but a dreamlike transcendentalist vision. "Romance of Autumn" (1916), "Romance of Criehaven" (1916), "Criehaven, Large" (1917), "Little House" (1920), "Windy Day" (1922), "The White Horse" (1922), "Old Farmyard, Toodleums" (1922), "Barnyard and Chickens" (1924), "The Picnic" (1924), "Old Lady's Home" (1924), "My House, Woodstock" (1924), and "The Picket Fence" (1924), the canvas Bellows was working on at the time of his death—these are startlingly beautiful, shimmering, and radiant; where the seacoast paintings celebrate the inhuman ferocity of natural forces, in which mankind is but one force in contention with others, these gentler paintings speak to a child's or a mystic's concept of Nature. The single life force that suffuses all things, the *currents of the Universal Being*, in Emerson's language, are here pacific, though ecstatic. Is this Bellows' paradise?—an expression of frank, paradisical yearning?

Consider "The White Horse": a large canvas of extraordinary subtlety and mystery. A single white horse stands in a farmyard, in the immediate foreground, oddly unpenned, untied; its back is to us as it gazes outward across a sweep of countryside, into a luminous sky. Our vision in the painting seems to be that of the white horse, whose simply rendered figure organizes the complex composition, giving it a solid if magical center of gravity, and balancing it with a narrow verti-

cal of white (the glimpse of a wood frame house at the right margin). Three red-brown chickens peck in the dirt, a single brown mongrel dog is poised close by. The atmosphere of "The White Horse" is tremulous, quivering; though painted in oils, it has the weightlessness and translucence, in its broad planes of color, of a swiftly executed watercolor; the recording of a moment in time, exquisite and ephemeral. *A mighty look runs round the World/And settles in the Hills.*

Is the "white horse" an emblem of the soul? Gazing, like the artist/viewer, into a miraculous landscape, paradise itself? Our gaze is drawn irresistibly to the watercolor wash of sky, the fantastical lacework frieze of clouds. The artistry of the sky. And the eerie tilt of the land, the slant of shadows. Is it nearing dusk, judging from the placement of shadows, or is it dawn? Distances, too, are unclear, as in the mind's eye and not in the eye itself; a house or barn at the horizon is as vividly depicted, in miniature, as the outbuildings of the farmyard before us. So too in the even larger and more exquisitely complex composition "Old Farmyard, Toodleums," an intense, dreamlike atmosphere prevails; though the scene is "real," the poetical mood is all, the evoking of an inner vision of which the outer forms, rendered with Bellows' customary craft, are but signs. What a powerful sensation of nostalgia these visionary dreamscapes evoke! What a world of wonders! The "paradise" paintings surely anticipate the quivering-animist watercolors of Charles Burchfield's less bizarre, more poetic work and, though very different in surface execution, the stylized rural visions shot with radiant light of Grant Wood. Two canvases executed on the Maine island of Criehaven in 1916 and 1917 share an identical, intensely pasto-

ral mood: in each, a chestnut-red horse is poised to the left, a figure of grace and beauty in a steep-hilled pasture, again a principle of organization for smaller, scattered shadowy-white shapes (calmly gazing sheep, a single cow). In each, the Atlantic Ocean is represented by a band of calm, pacific water shimmering to the horizon, its dark blue illuminated by the light of a rising, or a setting, sun. Except for the brilliantly colored horse and the blue ocean, the scene's numerous colors are subtle, understated. For this is an art of reflection and memory. Not what the eye sees but what our deepest wishes would yield, had they sufficient power.

In other of these ecstatic paradisical paintings—"Romance of Autumn" (in which, unusual for Bellows, lovers are depicted, a white-clad girl hand in hand with, though conspicuously elevated from, her well-dressed young man) and "My House, Woodstock," for instance—colors are wild, bold, passionate yet "pretty": flaming crimsons, oranges, bright greens, and deep rich improbable purples erupting out of the shadowed sides of mountains. A fauvist palette without the fauvist eroticism, and entirely free of the turbulence and threat of Bellows' better-known canvases.

How to connect such seductive visions of paradise with the hellish urban visions of strife and congestion painted by the same artist only a few years before? Is paradise but the obverse of hell? In these mesmerizing landscapes, it is the lushness of pure color that assaults the eye, crowds the canvas like the sweep of unstopped emotion.

## 20.    *The Search*

All the acts of life are the reordering, recognized or not, of phenomena, and the search for a finer reordering.

—George Bellows

## 21.     Self-Portrait: "Fisherman's Family (1923)

ONE OF Bellows' strangest canvases, originally painted in 1914 and reimagined almost a decade later, the large oil "Fisherman's Family" is not what its generic title suggests, but a portrait of George Bellows, his daughter Anne, and his wife Emma, fantasized as Monhegan Island natives. Its mood is heroic, even melodramatic, an idealized vision of the artist and his wife and daughter as they might be, if their circumstances of birth had been otherwise. Never has an artist's romantic yearning to be one with his subject, to enter into the very world of his art, been so revealed. *I am filled with awe, I am trying to paint my emotion about him.*

Like the equally ambitious and risky double portrait "Two Women" of the following year, "Fisherman's Family" conveys a mood of mysterious intensity. It is hardly a realistic portrait, but suggestive of allegory: man, woman, little girl posed against a backdrop of roiling Nature, white-capped surf in the near distance, an ominous sky beyond. This is an El Greco transposed to a Maine seacoast, a secular setting. Though nothing appears to be immediately threatening the family, the adults' stance—the protective gesture of the tall, well-formed man, the positioning of the woman beside him—suggests vigilance in the face of potential danger. (Note, too, the fisherman's handsome face, his utterly conventional appearance. Indeed, an idealized vision of Bellows by Bellows.) The sky is ominously heavy, swollen with unnaturally orange-red storm clouds; the atmosphere is of an imminent electric storm, reminiscent of the impending-storm canvases of Martin Johnson Heade (1819–

1904), with which Bellows may well have been familiar. The fisherman, his daughter on his shoulder, his wife beside him, stands on a promontory above an inlet where several fishermen (his companions-to-be?) are absorbed in preparing a fishing boat for launching. Atop a sea cliff at the far right stands a shore house, symbolically the fisherman's home which he must leave, to risk his life at sea; jutting out massively from the left is a foreboding cliff that blots out much of the sky and appears to be scintillating with lightning flashes. Only at the distant horizon is the sky clear and fair; nearer, the air appears agitated, and in the foreground, at the feet of the couple, the grass is strongly shadowed, contorted.

What could Bellows have intended, painting so ambitious, and so risky, a "family portrait"? There is something touching about the conceit of George Bellows, by this time a revered American painter, imagining himself, his wife, and his daughter as Maine natives of the working class. (Emma Bellows with her elegant appearance, her conspicuously stylish hair, is particularly unconvincing in the role.) Is this nostalgia for the primitive, a romantic yearning to return to one's (mythologized) roots? (Bellows' father was an Ohio businessman.) Does it imply a rejection of contemporary urban life, and of "culture," tantamount to a rejection of Bellows' public career? Or is it simply Bellows' fantasized identification with a type perceived as more manly than an artist; a wish that he might be a brother to the fishermen and shipbuilders of Maine whom he so much admired? Or did Bellows believe himself, in essence, a man of such qualities? The figure in the painting is very different from the Bellows of the photograph taken sometime before 1923, pro-

jecting a generalized masculinity, youthful and vigorous and conventionally attractive. (In the 1914 version, oddly, both the fisherman and his wife appear older, stockier, less distinguished; Emma's arm is upraised in a stereotyped gesture of alarm, and she is much less attractive.) The allegorical significance of man and family, man pitted against danger, man protecting his family against danger is self-evident, and the painting impresses us as a work of symbolic depth, however curious its autobiographical background. "Fisherman's Family" is a tour de force of audacious self-invention and self-definition.

Ironically, the painting is one of the last Bellows was to execute, in the busy year preceding his death.

## 22.   *Portraiture*

The model stand is the most searching place in the world.

—George Bellows

THROUGH HIS career, from his early student days to shortly before his death, George Bellows was fascinated by the possibilities of portraiture. His ambition to be a highly paid, highly regarded portraitist (in the tradition of Chase, Sargent, Whistler) was integral to his self-definition as an artist; more importantly, he seems to have understood that serious portraiture could be another means of inventing and defining himself, in this case in the projected vision of another. For all portraits are, in essence, self-portraits.

Of Bellows' estimated 700 works, approximately 140 are portraits. Though a number of these canvases rank among Bellows' most remarkable creations, as original and experimental as the works I have discussed, they seem to be little known today.

Like the greatest of portraitists—Goya, Velázquez, Rembrandt, Manet, Sargent, Whistler, and Eakins, among those he particularly admired—Bellows hoped to realize, by way of the intensely realized subject, the symbolic and generic. It is instructive that his commissioned portraits, primarily of men, are stiff, wooden, and unconvincing; only in his freely chosen work, undertaken not for money or reputation but in pursuit of an aesthetic and emotional ideal, does Bellows' genius assert itself. Here, in radically differing styles, from the elegantly romantic

canvases of early years to the rather harsh and defiant hyper-realism (in particular "Mr. and Mrs. Philip Wase," 1924) of the later years, Bellows cultivated yet another facet of his complex, ever-evolving personality.

And what an affinity Bellows had for women, girls, the *feminine* in its protean manifestations! Clearly, he was fascinated by, if not infatuated with, the essence of Woman. This so masculine man, notorious for his brutal, unsentimental boxing paintings and lithographs, a restless iconoclast of land- and seascapes, created, through his tragically abbreviated career, highly individualized and exquisitely rendered portraits of women of all ages, including the elderly; these deeply medita-tive, emotionally intense canvases are among the most brilliant portrayals of women in American art.

Bellows spoke impatiently of "the constant and foolish demand that pictures be 'beautiful'—as if Shakespeare [wrote only] love sonnets"; his focus was upon the expression of his subject's spiritual character, the mystery of personality itself. Yet virtually all his portraits of women exude a radiant sort of beauty, including the several fastidiously detailed and unsparing portraits of an elderly woman, "Mrs. T." (the first portrait shows Mrs. T. in her midseventies, the last in her mideighties). "Geral-dine Lee, No. 2" (1914), "Emma at the Piano" (1914), "Emma in an Orchard" (1916), "Emma in the Purple Dress" (1919), "Mrs. T. in Wine Silk" (1919), "Mrs. T. in Cream Silk" (1919–1923), "Anne in White" (1920), "Elinor, Jean and Anna" (1920), "Kath-erine Rosen" (1921), "Emma and Her Children" (1923), "Lady Jean" (1924), "Mr. and Mrs. Philip Wase" (1924), "Two Women" (1924)—these are works that transcend their genre, as

they transcend their place and time. Some are realistically con-ceived, others are more obviously impressionistic, with the intention of evoking emotion; the most delicately rendered (of young girls, images of innocence, including Bellows' much-painted daughters Anne and Jean) share some of the luminous-mystic quality of the "paradise" paintings.

Striking anomalies among Bellows' portraiture are two enigmatic and haunting canvases painted in the final year of his life: "Mr. and Mrs. Philip Wase" and "Two Women," each of which experiments with extending the perimeters of the genre, as each presents "doubled" portraits, figures seated together on a cushioned Victorian sofa who gaze steadfastly away from each other, like strangers not yet introduced. "Mr. and Mrs. Philip Wase" has the look of a photograph, resolutely unglam-orous, unsentimental; a mock-photograph, perhaps, pitiless in its depiction of an elderly married couple who appear to inhabit contiguous but not intersecting emotional worlds. Mrs. Wase is a stout, plain woman in an absurdly "feminine" dress, who stares worriedly at the viewer as if shrinking from judgment, her astonishingly literal hands, finely creased, loose in her ample lap; her stern-faced husband, dressed for the outdoors, wearing a cap though in a parlor, gazes off into the distance oblivious of her, as of his surroundings. Aged marital love! Between the Wases, conspicuous on the wall behind them like a third, unacknowl-edged presence, is an oval-shaped cameo of a severely dressed young woman, very likely Mrs. Wase of decades ago; to Mrs. Wase's right, perched just behind the sofa, is, of all things, a parrot, looking on with what might be seen as a parrot's shrewd eye. Is the parrot a symbol, and if so, of what? Or is the parrot

simply literal, Mrs. Wase's parrot, included in the painting by Bellows as a felicitous if mysterious detail—an artist's lucky find? The mood of the painting is one of pathos. There is something excruciatingly painful in the silent appeal of Mrs. Wase, a young woman trapped in an elderly woman's body, as she is trapped in the identity of "Mrs. Wase"—wife of the vacant-eyed, slack-faced old man seated beside her on the sofa, space conspicuous between them. Surely this disturbing double portrait is the model for Grant Wood's more commonly known "American Gothic" (1930)?

"Two Women" (originally titled "Two Sisters") is an equally mysterious and disturbing painting, a double portrait of a young woman (an idealized Emma Bellows?) seated on the identical Victorian sofa on which the Wases were seated, lost in reverie. Or is the woman dreaming? As the figure on the left, she is splendidly nude, except for a fragment of cloth trailing over her thigh and leg; her body creamy-pale, blooming with female health, as beautiful as Botticelli's Venus (whom in fact she resembles) or a figure of Titian or Rubens. Tiny lapdogs frolic at her bare, delicately poised feet. As the figure on the right, the woman is heavily clothed in Victorian lady's attire, a fur-trimmed crimson coat, with snug, warm-looking hat, and boots; she wears a single white glove and holds the other. Her skin is just perceptibly sallower than that of the nude and her expression is elegiac, inward. She might be in mourning, so still and deathly does she appear. Oddly, she shows not the slightest awareness of the glorious "classical" female nude beside her, as the nude shows not the slightest awareness of her. Again, Bellows is painting contiguous and unrelated selves: here, two

probable aspects of the (female) soul. They are not, and cannot be, in this claustrophobic interior, with its suggestion of a claustrophobic world beyond, *one woman*; they are doomed to be *two women*. Bellows presents this richly ambiguous scene, this unsettling vision, with painterly assurance, reveling in the profusion of details that surround the young woman and define her: Every inch of the canvas is filled with competing shapes, designs, fabrics, warring colors, as in a nightmare of conventional feminine *niceness*. Fussy ruffled curtains, rose-patterned carpet, a gilt-framed mirror reflecting a latticed window. The atmosphere is stifling, one can hardly breathe. Woman in essence, as she is in Nature; woman in her socially determined role as wife, mother, daughter, trapped in stifling, if expensive, clothing. *This is what I am*, the nude proclaims. *This is what I have become*, the clothed woman acknowledges.

What more devastating "feminist" vision, surely radical for its time?

Both "Mr. and Mrs. Philip Wase" and "Two Women" present human figures and their domestic surroundings as both realistic and allegorical; both strike the contemporary eye as hyperreal, if not surreal, hardly representative portraits or figure paintings of their time (see Bellows' opulent, self-reflecting nude on the very same Victorian sofa, "Nude with Hexagonal Quilt," 1924—a beautifully rendered and equally detailed work of a more conventional genre). These claustrophobic parlor interiors with their trapped figures, yearning to live, yet unmoving as works of art, painted with the weird precision of an Yves Tanguy, mock-"photographs" of Caucasian middle-class Americans—what did they presage of Bellows' work to come? What

wildly imaginative, provocatively iconoclastic canvases might Bellows have painted had he died, not in January 1925, but a quarter of a century later?

In any case, whatever symbolic or autobiographical secrets are coded in these portraits, they have been lost with Bellows' death.

## 23. *"Mrs. T. in Cream Silk, No. 1"*
### *(1919–1923)*

Time?—teaches us.

Time?—chastens us.

Time?—caresses us.

Time?—chisels us.

Time?—erodes us.

Time?—exposes us.

Time?—discloses us.

Time?—prepares us.

Time?—nourishes us.

Time?—catechizes us.

Time?—betrays us.

Time?—mythologizes us.

Time?—devours us

    in the name of Wisdom.

## 24.   "Dempsey and Firpo" (1924)

PAINTED IN the final year of Bellows' life, this large, monumentally conceived canvas quickly became one of the most famous of American twentieth-century works, the one with which, however reductively, the artist's name is perennially linked. People who know no other work of Bellows'—indeed, people who know virtually no artworks at all—recognize and admire "Dempsey and Firpo."

Where the early boxing paintings, of 1907–1909, were executed with the intention of evoking emotion as if one were present at ringside, confused by the nightmare action, the later boxing paintings, "Ringside Seats" (1924) and "Dempsey and Firpo," are formal, intellectualized compositions, comprised of sculpted slow-motion forms. They strike the eye as not unreal precisely, but bearing the sort of tangential relationship to reality one sees in a painting by a great European modernist like Matisse, Beckmann, Balthus. (The bizarre domed head and exaggerated features of the ringside spectator at the far left in "Dempsey and Firpo" look like something out of Peter Blume.) Bellows' mythmaking intentions are clearer here, where the painting, for all its stylized motion, has an eerie, friezelike quality, like a Diego Rivera mural. Only the outward trappings of photographic/journalistic "realism" are preserved.

By 1924, boxing was legalized in New York State. The atmosphere of "Ringside Seats" in the old Madison Square Garden and "Dempsey and Firpo" at the Polo Grounds is dramatically different from that of the squalid private clubs. Here, as in works by Eakins, boxing has pretensions of being a sport;

even, in the formally composed "Ringside Seats," with its youthful, handsome boxers and its well-to-do spectators—note the man in black-tie at the far right—a gentlemanly sport. In the 1920s boxing was immensely popular, revitalized by the young and seemingly invincible heavyweight Jack Dempsey, who won his title in 1919 in one of the great upsets—and one of the most savage fights—in boxing history. (Dempsey knocked down his opponent, Jess Willard, seven times in the first round alone.) In what is known as the Dempsey Era, as many as 100,000 spectators would pay to see a title match involving Dempsey—the champion whom everyone loved, or loved to hate. Indeed, if "Dempsey and Firpo" is the most reproduced of Bellows' paintings, it is probably because of Dempsey's charisma, and not Bellows' talent; though, ironically, Bellows has captured the heavyweight titleholder in the most inglorious, and controversial, incident in his career.

"Dempsey and Firpo" records a moment now legendary: when, in the first, tumultuous round of the five-minute title fight, the clumsy Argentinian giant Luis Firpo knocked or, it's generally believed, pushed the champion Dempsey through the ropes and onto the ring apron. By this time Dempsey had already been knocked down twice by Firpo's wild roundhouse swings, even as Firpo, the much-hyped "Wild Bull of the Pampas," had been knocked down an extraordinary seven times; at which point, acting out of sheer desperation, the dazed Firpo managed to stagger to his feet, avoided Dempsey's frenzied assault, and by trapping him in the ropes, knocked (or pushed) him out onto the ring apron. In boxing history, the fight remains controversial because it is not clear whether Dempsey could

have climbed back into the ring unaided by the count of ten. As legend has it, the *Tribune* reporter whose typewriter Dempsey had fallen on helped push him back inside, and Dempsey resumed the fight with renewed savagery. In the second round, he knocked Firpo down for a count of ten to retain his heavyweight title. Seen on film, decades later, this infamous fight appears so violent it verges upon the surreal, or the blackly comic: Its rhythms, exaggerated by the film medium, are comically percussive, machinelike. Dempsey's characteristic ring style was nonstop offense with no pretensions of defense. He was a fighter who knew only to go forward. So aroused was he, it's said, by the very act of fighting, he seems to have had no awareness of fouling his opponents, breaking ring rules, nor did he much mind, or perhaps even notice, being fouled in return. Never a "boxer" in the style of his distinguished predecessor Gentleman Jim Corbett, or of his successor Gene Tunney, Dempsey galvanized immense crowds by the sheer aggression of his fighting: He seems to have wanted to kill anyone challenging him in the ring. Most of his pre-Tunney fights, like this one with Firpo, would have been stopped early in the first round if they had taken place later in boxing history. Out of such macho materials, the Dempsey legend.

By choosing to paint "Dempsey and Firpo" in a smoothly stylized manner, Bellows makes no attempt to communicate the poetic essence of the fight, and of the fight's atmosphere; there is no suggestion in Firpo of the injured boxer's manic desperation, nor is Bellows probably accurate in showing Firpo having swung what appears to be a roundhouse left—surely it was an overhand right? Seen from the back, Bellows' Dempsey might

be any generic boxer; atypically pale for Dempsey, who trained out-of-doors and tanned darkly. Though the 88,000 spectators jammed into the Polo Grounds were said to have been hysterical by the time the American champion fell through the ropes, Bellows' ringside spectators express little more than gentlemanly surprise and concern; they are so slickly executed as to resemble fashion mannequins.

Of course, "Dempsey and Firpo" is a work of the imagination, not journalism. It is under no obligation to be faithful to the historic event from which it derives. And there is something haunting, and indeed mythic, in these stiff, frozen figures—the statuesque Firpo with his improbably unbloodied, composed face; the helplessly plunging Dempsey with his slicked-down black hair; the referee, however impossibly, already in midcount; the flat tonalities of the colors; the compulsive painterly detail in, for instance, the newspapermen's clothing and the ring ropes. No figure strikes the eye as *alive*, let alone involved in a frenzied dramatic action—but perhaps that was the artist's point. That the Dempsey-Firpo match *was* unreal, best memorialized as illustration.

## 25. Bellows' Final Vision: "The Picket Fence" (1924)

EXECUTED IN the luminous, shimmering, intensely personal style of the canvases I've characterized as "paradisical," most of them inland, or bounded by an idyllic sea, "The Picket Fence" is Bellows' last painting, and is said to have been completed by an artist-friend, Eugene Speicher, after Bellows' sudden death.

What an extraordinary vision with which to end a career of such virtuosity! So different in tone, style, emotion from the monumental "Dempsey and Firpo," as from the mock-photographic literalness of "Mr. and Mrs. Philip Wase" and "Two Women" as to seem the work of another, wholly unrelated artist, "The Picket Fence" is a consoling fantasy of soft, bright, springlike colors; a fantasy of home, one home among others along an idyllic country road. Except for its rural setting, the wood frame house of this painting somewhat resembles Bellows' family house of long-ago Columbus, Ohio. It seems literally to glow with a pale yellow light. All of Nature blooms about it—pastel reds, pinks, a brilliant clear watercolor wash of sky, thrumming with invisible life. Not contentious, erotic life, but placid life. The life of the womb, the life of undifferentiated identity. However far one has journeyed, here one has come home. *Once upon a time* such a fable begins. *Happily ever after* such a fable ends.

In the midst of this storybook landscape the only sight that jars is an upraised cellar door, improbably placed at the end of the truncated front walk; only a few yards from the equally truncated, hardly more than ceremonial picket fence. Why does

the front walk lead, not to a door, but to the dark-shadowed cellar opening? And why is the door opened? Not the picket fence but the cellar opening is the thematic focus of the painting, the point to which, uneasily, our gaze moves. Once you see the cellar door there, at the end of the front walk, you can't not see it. The painting is dramatically rearranged.

What lies within that gravelike dark hole, where do the invisible steps lead?—from our perspective outside the picket fence, on the country road, in the luminous light, we can't see.

*The artist's trade, illimitable experience.*

## Notes

Chapter 1. In disclaiming any knowledge of boxing, Bellows
was being disingenuous. In fact, between 1907 and 1924,
he executed numerous paintings and lithographs of boxers
that reveal both a technical familiarity with boxing culture
and an emotional intimacy with its dramatic admixture of
triumph and pathos. These include, in addition to the early
canvases discussed, the paintings "Both Members of This
Club" (1909), "Ringside Seats" (1924), and "Dempsey and
Firpo" (1924), and the lithographs "Training Quarters,"
"Preliminaries," "Between Rounds," "Introducing the
Champion," "Introducing John L. Sullivan," "A Knock-
Out," "The Last Count," "Counted Out," "The White
Hope," "Introductions," "Introducing Georges Carpen-
tier," and versions of "Dempsey and Firpo." Unlike
Thomas Eakins, who depicted gentlemanly Caucasian ath-
letes in comparatively open, well-lit spaces, Bellows
focused upon the physical *agon* of the boxers; these are not
athletes in any middle-class sense of the term, but men
fighting for their lives. Appropriately, Bellows' boxing
spaces are crowded, claustrophobic, the images of night-
mare, not "sport." Maliciously grinning faces like
illuminated balloons appear and disappear in the shadowy
backgrounds, as in a delirium of the struggling boxers
themselves.

Bellows' boxing prints were enormously popular,

awaited with anticipation, and rapidly sold out their editions. The print version of "Stag at Sharkey's" is considered by art historians the most famous American print of the twentieth century (see *George Bellows: The Boxing Lithographs*, N.G. Stogdon, Inc., New York, 1988. Introduction by N.G. Stogdon and Susan Lewis Kaye).

Chapter 5. *There are no successful pictures without a geometrical basis*, Bellows once declared. For thorough, illustrated discussions of Bellows' career-long experimentation with theories of composition and color, see "Technique and Theory: The Evolution of George Bellows' Painting Style," in *The Paintings of George Bellows* (Harry N. Abrams, Inc., New York, 1992) and *George Bellows*, by George W. Eggers (Whitney Museum, 1931).

Chapter 9. Quotations are drawn from "The 'Real' New York," Marianne Doezema, in *The Paintings of George Bellows* (Harry N. Abrams, Inc., New York, 1992).

Chapter 12. Quotation from a letter of Bellows to his wife Emily. In "Bellows and the Sea," Franklin Kelly.

Chapter 17. Quotations from "Bellows and the Sea," Franklin Kelly.

Chapter 18. Quotation from "Bellows and the Sea," Franklin Kelly.

Chapter 20. Quotation from *The Paintings of George Bellows* (Knopf, New York, 1929).

Chapter 22. Epigraph from *Portraits by George Bellows*, Margaret C.S. Christian (National Portrait Gallery, Smithsonian Institution, 1981). (The beautiful family portrait "Elinor, Jean and Anna"—three generations of females, Bellows' aged

mother, his young daughter Jean, and his middle-aged aunt—brought Bellows the highest fee he was to receive for any work of art: after gallery commission, $6,500.)

Chapter 23. Bellows' fascination with Woman resulted in a number of memorable portraits of middle-aged and elderly women, of which the "Mrs. T." series is perhaps the most striking. In all, Bellows painted three portraits of Mrs. Mary Brown Tyler, a widow, of a prominent Illinois family, between 1919 and 1923, capturing the subtle progress of her aging. His fastidious depiction of Mrs. Tyler in her painfully "feminine" costume is a masterpiece of detail, communicating a profound emotion; the subject is terribly aged, yet possesses dignity and strength of character at the very brink of physical dissolution. At the time of "Mrs. T. in Cream Silk," Mrs. Tyler was well into her eighties, here posed in her elegant cream silk wedding gown of 1863. What pathos, and what beauty, in this woman's face! her remarkable dark-dilated eyes! Bellows' depiction of the elderly Mrs. Tyler, clothed in the luxury of her privileged life, in the very dress in which, a lifetime ago, she became a bride, is both a commentary on aging and a dramatic presentation of it. (Ironically, though Mrs. Tyler is said to have liked the portraits, her family thought them "not a good likeness"—that is, not flattering—and rejected two of them, with the further admonition that their family name be deleted from the titles.)

Chapter 25. Why did George Bellows die?—so needlessly, and prematurely? From August 1924 to January 1925, a remarkable period of time, he had known that his appendix

was dangerously inflamed and might rupture at any time; yet he'd resisted medical treatment, made light of the severe pain with which he lived—for what tragic reasons of stoicism, death-denial, sheer masculine stubbornness one can only guess. In his New York home at the time (146 East Nineteenth Street), he continued to work as usual at his art, no doubt imagining (for such delusions are part of the artist's strategies of art, without which he would surrender much of his power) that he might, through sheer inspiration and genius, paint his way out of a merely physical predicament. Bellows was tearing up rotted boards from his studio floor when his appendix finally burst. He died in a New York hospital following emergency surgery a few days later.

## Works Cited or Consulted

Braider, Donald. *George Wesley Bellows and the Ashcan School of Painting.* New York, 1971.

Christian, Margaret C. S. *Portraits by George Bellows.* National Portrait Gallery, Smithsonian Institution, 1981.

Eggers, George W. *George Bellows.* New York: Whitney Museum, 1931.

*George Bellows: Paintings, Drawings and Lithographs.* New York: H. V. Allison Galleries, 1984.

*George Bellows: Paintings, Drawings and Prints.* Chicago: Art Institute of Chicago, 1946.

*George Bellows: The Boxing Lithographs.* Intro. by N. G. Stogdon and Susan Lewis Kaye. New York: N. G. Stogdon, 1988.

Malone, Lee. *George Wesley Bellows: Paintings, Drawings and Prints.* Columbus, Ohio: Columbus Museum of Art, 1979.

*The Paintings of George Bellows.* New York: Alfred A. Knopf, 1929.

*The Paintings of George Bellows.* Essays by Mickael Quick, Jane Myers, Marianne Doezema, and Franklin Kelly. Intro. by John Wilmerding. New York: Harry N. Abrams, 1992.

Rose, Barbara. *American Art Since 1900: A Critical History.* New York: Frederick A. Praeger, 1967.

## About the Author

Joyce Carol Oates is the author of numerous works of fiction, poetry, criticism, and drama, several of which have appeared under the Ecco Press imprint: *The Assignation* and *Where Is Here?* (short fictions), *The Perfectionist and Other Plays*, the novella *I Lock My Door upon Myself*, and the updated edition of *On Boxing*. She is the author most recently of the novels *Zombie* and *What I Lived For*. A past recipient of the National Book Award and a member of the American Academy of Arts and Letters, she is the Roger S. Berlind Distinguished Professor in the Humanities at Princeton University.

# DATE DUE